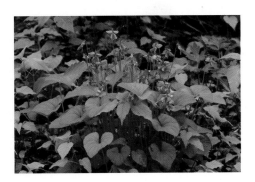

A WRITER'S GARDEN

INSPIRED PHOTOGRAPHS
WITH SELECTED WRITINGS BY L. M. MONTGOMERY

PHOTOGRAPHS BY
ANNE MacKAY AND WAYNE BARRETT

TEXT SELECTED BY SANDRA WAGNER

December 2004
From Bill & Anne ?
Brownie Farm, P.E.I.
To kindred spirits.

NIMBUS
PUBLISHING

Nimbus Publishing Limited
PO Box 9166
Halifax, NS
B3K 5M8
(902) 455-4286

Design: Kate Westphal, Graphic Detail Inc., Charlottetown, PE

Printed and bound in Canada

Library and Archives Canada Cataloguing in Publication

Montgomery, L. M. (Lucy Maud), 1874-1942.
A writer's garden : inspired photographs with selected writings by
L. M. Montgomery / writings by L. M. Montgomery ; selected by Sandy Wagner ;
photographs by Anne MacKay and Wayne Barrett.

ISBN 1-55109-502-5

1. Gardens—Prince Edward Island—Pictorial works. 2. Montgomery,
L. M. (Lucy Maud), 1874-1942. I. Wagner, Sandy II. MacKay, Anne III. Barrett, Wayne IV. Title.

PS8526.O55A6 2004 712'.6'09717 C2004-905141-5

The Canada Council | Le Conseil des Arts
for the Arts | du Canada

Canadä

We acknowledge the financial support of the Government of Canada through the Book Publishing Industry Development Program (BPIDP) and the Canada Council for our publishing activities.

CONTENTS

ACKNOWLEDGEMENTS

We wish to acknowledge the following locations where endless hours were spent photographing gardens: Orwell Corner Historical Site; Beaconsfield Historic House; Ardgowan National Historic Site of Canada; Anne of Green Gables Museum; Perennial Pleasures Country Garden; Lower Bedeque School; Fanningbank, Government House; The Inn at Bay Fortune; Green Gables, PEI National Park; The Dunes Studio Gallery; L. M. Montgomery Birthplace; Veseys Seed Company; Lucy Maud Montgomery Historical Site. We also thank Heather Ramsay for her good-natured assistance during the preparation of this book; Sarah and Rik Barron; Judge Kenneth MacDonald; Theresa Doyle; Joe Dolphin and Trudy Oliver; Donald and Audrey MacKay; and Confederation Centre of the Arts for permission to use our photo of L. M. Montgomery's scrapbook.

We thank George Campbell for coming to us with the concept for this book. We especially thank all the Prince Edward Islanders who openly share their love of gardening with the rest of us.

For further information on the locations and flora pictured here, please contact info@barrettmackay.com.

Anne MacKay & Wayne Barrett

Sincere appreciation to David Macdonald, trustee, and Ruth Macdonald, the heirs of L. M. Montgomery for quotations used from the novels of L. M. Montgomery.

My thanks to George Campbell of Silver Bush, who knowing of my love of the writings and places of L. M. Montgomery thoughtfully asked me to choose the quotes accompanying the photographs. My thanks also to Ruth Hunter for her time, meticulous typing and kind suggestions.

The love of nature and gardening flowers was instilled in early childhood walks with my mother. Bouquets of my grandmother's velvet-faced pansies and a good book always ended those days. Without their influence I may not have grown to fully appreciate "the haunts of ancient peace" that L. M. Montgomery wrote of and the beauty of fine photography.

Sandra (Sandy) Wagner

INTRODUCTION

Nestled in the Gulf of St. Lawrence, between Nova Scotia and New Brunswick, sits one of the most visually stunning and culturally significant places in Canada.

Prince Edward Island is only 5,660 square kilometres, but its red earth, blue shores, green trees, and golden fields draw thousands of visitors each year. Its glorious summer attracts the most tourists, but lucky are those who witness the Island's boisterous spring and slow-waning fall. And in the winter, the crisp white snow settles itself across the muted island, smoothing edges and rounding corners. My favourite time of year is late June and early July when the lupins are in their full glory, seemingly filling every ditch along every road on the Island with a multitude of whites, pinks and purples.

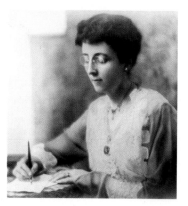

On the North Shore, against one of Canada's loveliest beaches, one of the country's most celebrated authors drew her inspiration. L. M. Montgomery described the Island this way:

Much of the beauty of the Island is due to the vivid colour contrasts – the rich red of the winding roads, the brilliant emerald of the uplands and meadows, the glowing sapphire of the encircling sea. It is the sea which makes Prince Edward Island in more senses than the geographical. You cannot get away from the sea down there. Save for a few places in the interior, it is ever visible somewhere, if only in a tiny blue gap between distant hills, or a turquoise gleam through the dark boughs of spruce fringing an estuary. (The Alpine Path)

Born on November 30, 1874, to Hugh John Montgomery and Clara Woolner Macneill, Lucy Maud Montgomery was left in the care of her maternal grandparents after Clara died. Alexander and Lucy Macneill lived in Cavendish. Cavendish was one of the prettiest communities on the Island, with rolling golden fields, lovely woodlands and, within a stone's throw, the most magnificent seashore with beautiful arches and caves formed by the constant thrust of the saltwater against the sandstone cliffs.

L. M. Montgomery's grandparents were quite strict, and Maud (as she liked to be called) was rarely allowed to attend social functions—even her membership in the Literary Society was discouraged. Isolated from her peers and misunderstood by her family, she longed desperately for a "kindred spirit." The same gift that later made her a famous author served her well in these early years, as Maud made the loneliness bearable through her own creativity. She didn't wither under her grandparents' stern gaze, but turned to the world of her vivid imagination. She turned her community into a sparkling playground filled with inventive images. Maud wrote stories about the world around her—a pretty wooded path became Lovers' Lane, one of her most cherished places on the Island; and the spruce grove in the field below the orchard

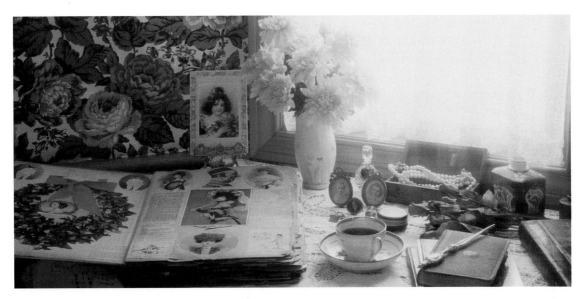

became the Haunted Wood, to name but two examples. Trees, brooks, beaches and flowers all had their own personalities to her. The old birch on the southern edge of the Haunted Wood was named The Monarch of The Forest by Maud. This tree had been the subject of one of her very early poems, written when she was only nine. Another early poem called "The Tree Lovers" was inspired by the "The Lovers," her name for two trees behind the barn at the Macneill homestead. A spruce and a maple tree grew so close to one another that their boughs became intertwined and woven together and "The Lovers" lived happily for many years until the maple died. The spruce held the dead form of the maple for two more years until he died from a broken heart, according to the romantic Maud.

At fifteen, Maud moved to Saskatchewan to live with her father and his new wife. She became desperately homesick—not only for her grandparents and her friends, but for the land of Prince Edward Island itself. She wrote to her friend Penzie Macneill:

Often in my dreams, I see the dear old shore with its brown rocks and pebbled coves and the blue waters of the sparkling gulf…I long to see those dear old lanes and woodland paths again under the maples and birches, beeches and poplars…I've seen a good many places since I left home and I tell you I haven't seen one prettier or nicer than Cavendish….

She returned to Cavendish after just a year in Saskatchewan.

Maud became a teacher in 1896, and taught in a few communities around Prince Edward Island before moving to Halifax to study at Dalhousie. Soon, though, her grandfather died, and she was called home to take care of her grandmother. She briefly returned to Halifax to work at the *Daily Echo*, but again moved back to the Island to live with Grandmother Macneill and help run the post office, which was attached to the Cavendish home. In 1910 Maud wrote a lovely description for *Canadian Magazine* about evening in her grandmother's garden:

But the evening was more beautiful still, when the sunset sky was all aglow with delicate shadings and a young moon swung above the sea in the west. The robins whistled in the firs, and over the fields sometimes come lingering music from the boats in the bay. We used to sit

on the old stone wall and watch the light fading out on the water and the stars coming out over the sea. And at last grandmother would come down the honeysuckle path and tell us it was time that birds and buds and babies should be in bed. Then we would troop off to our nests in the house, and the fragrant gloom of a summer night would settle down over the Garden of Old Delights.

Maud lived with her grandmother at the Macneill homestead until her grandmother's death in March of 1911. Secretly engaged since 1906, Maud and the Reverend Ewan Macdonald married in the summer of 1911 and soon moved to the manse at Leaskdale, Ontario.

Through all the many challenges of her life, Maud found special solace in two things: her love of the glorious natural world that surrounded her, and her writing. By 1901 she was making a fair living writing essays and stories for magazines across North America; in 1908, her first novel was published. *Anne of Green Gables* was instantly popular, and its spritely, passionate heroine continues to be one of the best-loved literary figures in the world. Like Maud, Anne is captivated by the beauty of Prince Edward Island:

'I'm so glad my window looks east into the sun-rising,' said Anne, going over to Diana. 'It's so splendid to see the morning coming up over those long hills and glowing through those sharp fir tops. It's new every morning, and I feel as if I washed my very soul in that bath of earliest sunshine.'

In all of her novels, Maud includes vivid and loving descriptions of landscapes and the surroundings of nature.

Her novels and stories leave little room for doubt about her devotion to the beauty of Prince Edward Island, but we also find proof in her journals and letters. Maud began keeping

a journal at the age of nine and, though she destroyed her earliest diaries, four volumes of her *Selected Journals* have been published to date. She was also a devoted pen friend for forty years to Ephraim Weber and George Boyd MacMillan, and her two collections of letters *The Green Gables Letters* and *My Dear Mr. M* have also been published since her death. Her journals and letters brim with her awe of and love for the natural world. Her descriptions of sunsets, of woods, and of gardens are intense and passionate. In a letter to her friend Mr. Weber on May 8, 1905, she writes:

Today I read that Henry Ward Beecher said once 'flowers are the sweetest things God ever made and forgot to put souls into.' But I don't believe He forgot! I believe they have souls. I've known roses that I expect to meet in heaven.

Maud never stopped missing her island home, and repeatedly declared that there was no place more beautiful in the world. I know from listening to my father's family stories that his mother, my grandmother, L. M. Montgomery, favoured spring, though she truly loved all the seasonal changes of the Island. She writes to her dear Mr. M:

Well I like autumn too. Indeed I think every season has dear lovable charms of its own, and I'm sure I'd get frightfully tired of everlasting summer. A Canadian winter has a wonderful zest and sparkle and even the storms have a wild white majesty of their own. A still winter evening among the wooded hills with the sunset kindling great fires in the westering valleys is something I would not exchange for a month of hot July days.

August 2004
Kate Macdonald Butler

Spring

There we sat and stripped th

making up the blossoms into bou

MAYFLOWERS

Mayflowers, you must know, never flaunt themselves; they must be sought as becomes them, and then they will yield up their treasures to the seeker—clusters of star-white and dawn-pink that have in them the very soul of all the springs that ever were, re-incarnated in something it seems gross to call perfume, so exquisite and spiritual is it.

When the sun began to hang low, sending great fan-like streamers of radiance up to the zenith, we foregathered in a tiny, sequestered valley, full of young green fern, lying in the shadow of a wooded hill. In it was a shallow pool—a glimmering green sheet of water on whose bank nymphs might dance as blithely as ever they did on Argive hill or in Cretan dale. There we sat and stripped the faded leaves and stems from our spoil, making up the blossoms into bouquets to fill our baskets with sweetness. The Story Girl twisted a spray of divinest pink in her brown curls, and told us an old legend of a beautiful maiden who died of a broken heart when the first snows of winter were falling, because she believed her long-absent lover was false. But he came back in the spring time from his long captivity; and when he heard that she was dead he sought her grave to mourn her, and lo, under the dead leaves of the old year he found sweet sprays of a blossom never seen before, and knew that it was a message of love and remembrance from his dark-eyed sweetheart.

The Golden Road

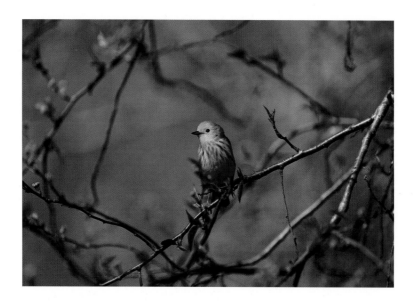

YELLOW WARBLER

The garden was full of birds; some of them we regarded as old friends for they nested in the same place every year and never seemed afraid of us. One exciting summer a pair of hummingbirds built a nest in the central honeysuckle arch. A wild August gale and rainstorm tore it from its frail hold and dashed it to the ground, where we found it the next morning. We girls cried over it; and then we cast lots to decide who should have the wonderful thing, fashioned of down and lichen, and no bigger than a walnut. The hummingbirds never came back, though we looked wistfully for them every summer.

"A Garden of Old Delights"

I think I'd

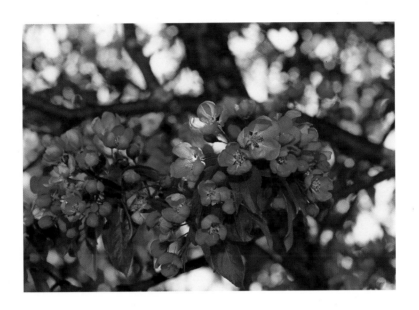

APPLE BLOSSOMS

"Oh, look, here's a big bee just tumbled out of an apple blossom. Just think what a lovely place to live in an apple blossom! Fancy going to sleep in it when the wind was rocking it. If I wasn't a human girl I think I'd like to be a bee and live among the flowers."

Anne of Green Gables

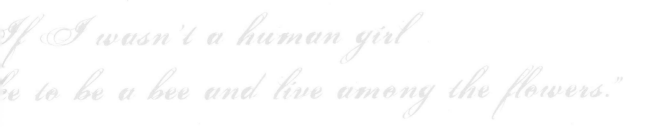

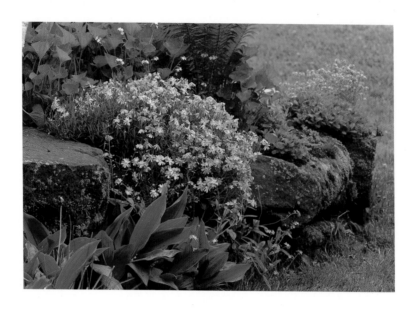

ISLAND STONE

Most of the orchard was grown over lushly with grass; but at the end where Eric stood there was a square, treeless place which had evidently once served as a homestead garden. Old paths were still visible, bordered by stones and large pebbles. There were two clumps of lilac trees; one blossoming in royal purple, the other in white. Between them was a bed ablow with the starry spikes of June lilies. Their penetrating, haunting fragrance distilled on the dewy air in every soft puff of wind. Along the fence rosebushes grew, but it was as yet too early in the season for roses.

Kilmeny of the Orchard

Their penetrating, hau

air in every soft puff of wi

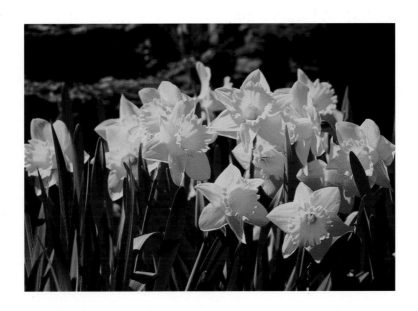

DAFFODILS

"Susan, after I am dead I'm going to come back to earth every time when the daffodils blow in this garden," said Anne rapturously. "Nobody may see me, but I'll be here. If anybody is in the garden at the time—I think I'll come on an evening just like this, but it might be just at dawn—a lovely, pale-pinkly spring dawn—they'll just see the daffodils nodding wildly as if an extra gust of wind had blown past them, but it will be I."

Rainbow Valley

ing fragrance distilled on the dewy

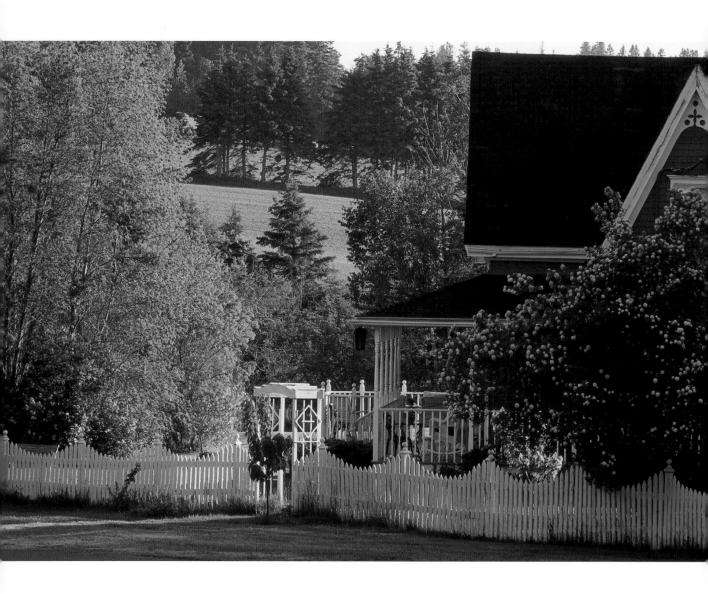

The air was like a thin yol

WHISPERING WINDS

The air was like a thin golden wine and the quiet was a benediction.

Margaret caught her breath with the delight of it.

Whispering Winds was one of those houses you loved the minute you saw them, without being in the least able to tell why—perhaps because its roof-line was so lovely against the green hill. She loved it so. She walked about the old garden, that was beginning to have such a look of neglect. She longed to prune it and weed it and dress it up. That delightful big bed of striped grass was encroaching on the path, those forget-me-nots were simply running wild. They and the house were just crying out for someone to take care of them. The house and the garden belonged together in some way—you couldn't have separated them. The house seemed to grow out of the garden. The shrubs and vines reached up around it to hold it and caress it.

A Tangled Web

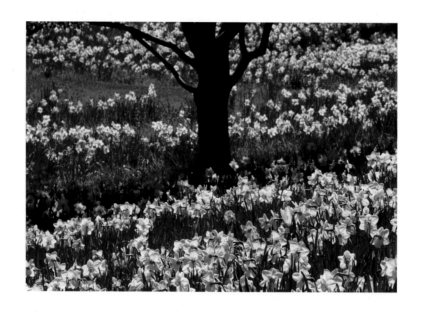

NARCISSI

"Let's sit right down here among the narcissi...Why, girls, there are hundreds of them...they've spread over everything. It looks as if the garden were carpeted with moonshine and sunshine combined. This is a discovery worth making. To think that I've lived within a mile of this place for six years and have never seen it before!"

Anne of Avonlea

"It looks as if the garden were and sunshine combined."

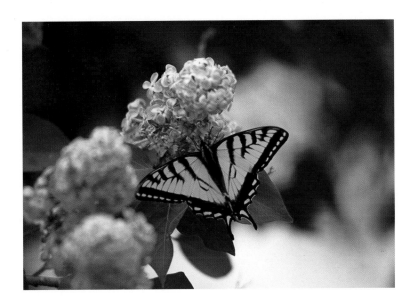

L I L A C S

"This is a veritable haunt of ancient peace," quoted Eric, look-ing around with delighted eyes. "I could fall asleep here, dream dreams and see visions. What a sky! Could anything be diviner than that fine crystal eastern blue, and those frail white clouds that look like woven lace? What a dizzying, intoxicating fragrance lilacs have! I wonder if perfume could set a man drunk...

Kilmeny of the Orchard

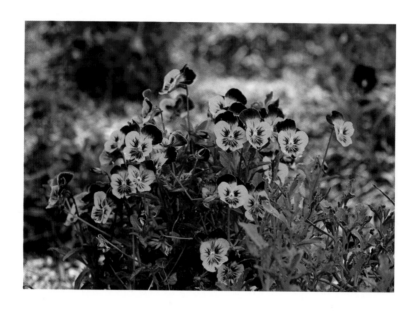

PANSIES

And finally May was June, with a fairy wild plum hanging out
in the Whispering Lane and purple waves of lilac breaking along
the yard fence and Judy's beds of white pansies all ablow…big
white, velvety pansies…and everywhere all different shades of
green in the young spring woods on the hill.

Pat of Silver Bush

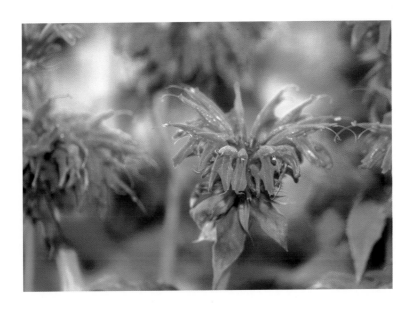

BEE BALM

What fairy things the seeds of immortelles were! What a lovely name "bee balm" was! It was on evenings like this long ago she had listened for Joe's whistle as he came home from work. There was never any whistle now…Sid never whistled.

Mistress Pat

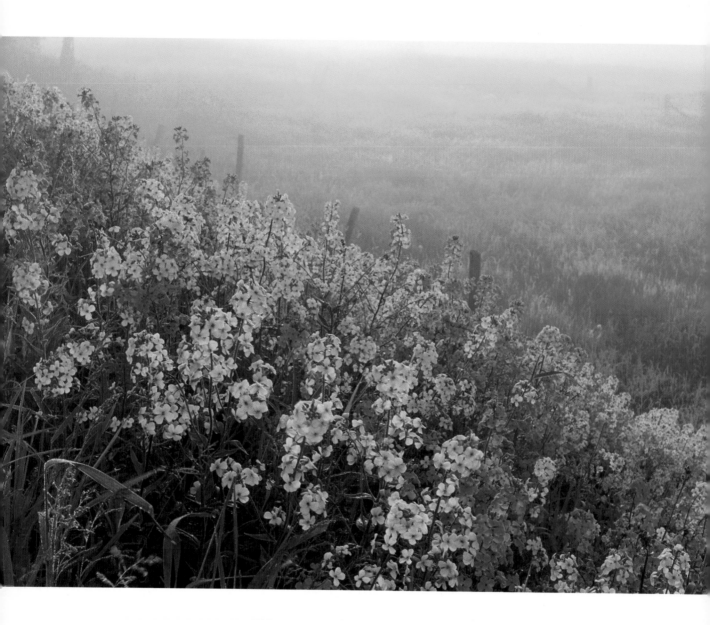

PHLOX

Early morning was an exquisite time in the garden. Delicate dews glistened everywhere and the shadows were black and long and clear-cut. Pale, peach-tinted mists hung over the bay and little winds crisped across the fields and rustled in the poplar leaves in the wild corner. But the evening was more beautiful still, when the sunset sky was all aglow with delicate shadings and a young moon swung above the sea in the west. The robins whistled in the firs, and over the fields sometimes came lingering music from the boats in the bay. We used to sit on the old stone wall and watch the light fading out on the water and the stars coming out over the sea.

"A Garden of Old Delights"

The robins whistled in the firs, and over the fields sometimes came lingering music from the boats in the bay.

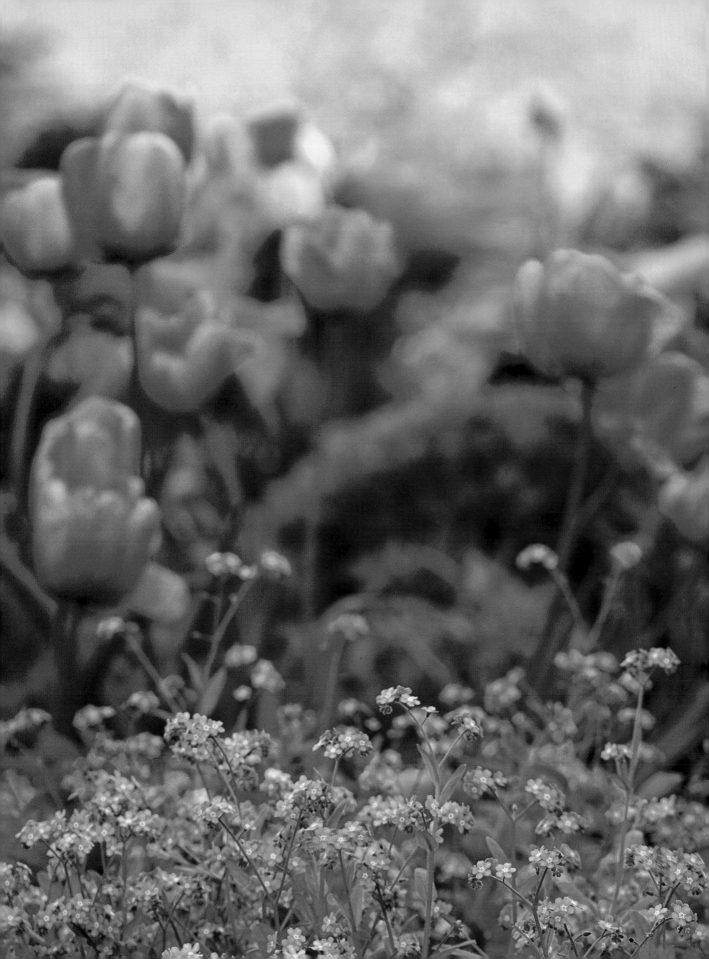

TULIPS

"…I'll tell you a pretty little story the Awkward Man told us— told me—tonight. He was walking in his garden as we went by, looking at his tulip beds. His tulips are up ever so much higher than ours, and I asked him how he managed to coax them along so early. And he said he didn't do it—it was all the work of the pixies who lived in the woods across the brook. There were more pixy babies than usual this spring, and the mothers were in a hurry for the cradles. The tulips are the pixy babies' cradles, it seems. The mother pixies come out of the woods at twilight and rock their tiny brown babies to sleep in the tulip cups. That is the reason why tulip blooms last so much longer than other blossoms. The pixy babies must have a cradle until they are grown up. They grow very fast, you see, and the Awkward Man says on a spring evening, when the tulips are out, you can hear the sweetest, softest, clearest, fairy music in his garden, and it is the pixy folk singing as they rock the pixy babies to sleep."

The Golden Road

The tulips are the pixy babies' cradles, it seems.

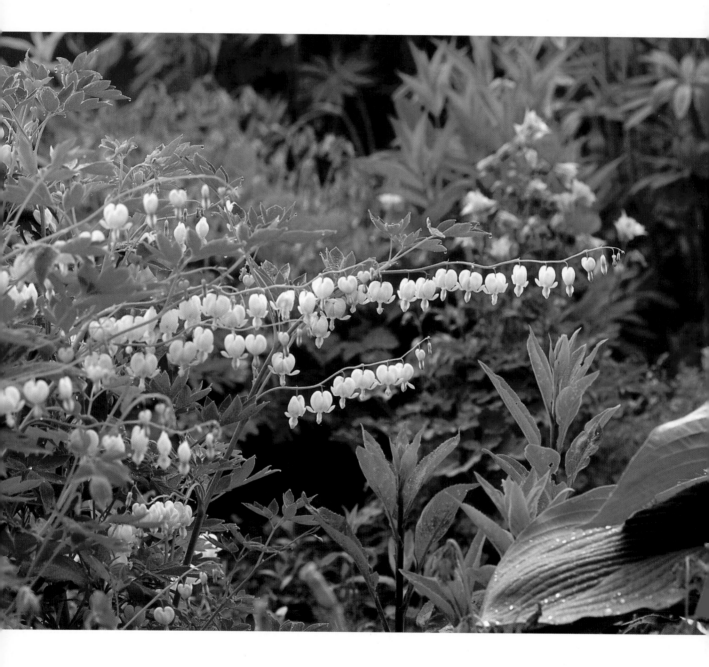

BLEEDING HEART

She went out to the neglected garden and picked a bouquet of bleeding-heart and June lilies for the centre. There was nothing to hold them, but Jane found a rusty old tin can somewhere, swathed it in a green silk scarf she had dug out of her trunk…it was an expensive silk scarf Aunt Minnie had given her…and arranged her flowers in it.

Jane of Lantern Hill

She went out to the neglected garden and picked a bouquet of bleeding-heart and June lilies for the centre.

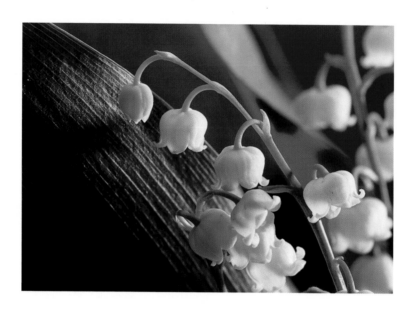

LILY-OF-THE-VALLEY

"This is what I would once have called an epoch in my life," said Anne, as she took Roy's violets out of their box and gazed at them thoughtfully. She meant to carry them, of course, but her eyes wandered to another box on her table. It was filled with lilies-of-the–valley, as fresh and fragrant as those which bloomed in the Green Gables yard when June came to Avonlea. Gilbert Blythe's card lay beside it.

Anne of the Island

It was filled with lilies-of-the–valley, as fragrant as those which bloomed in the Green yard when June came to Avonlea.

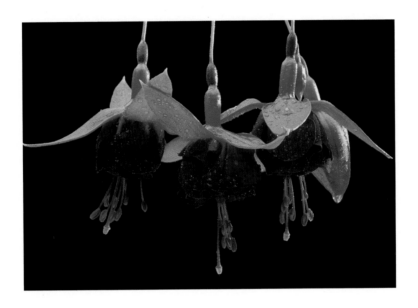

LADIES EARDROPS

Mrs. Rachel Lynde lived just where the Avonlea main road dipped down into a little hollow, fringed with alders and ladies' eardrops and traversed by a brook that had its source away back in the woods of the old Cuthbert place; it was reputed to be an intricate, headlong brook in its earlier course through those woods, with dark secrets of pool and cascade; but by the time it reached Lynde's Hollow it was a quiet, well-conducted little stream, for not even a brook could run past Mrs. Rachel Lynde's door without due regard for decency and decorum; it probably was conscious that Mrs. Rachel was sitting at her window, keeping a sharp eye on everything that passed, from brooks and children up, and that if she noticed anything odd or out of place she would never rest until she had ferreted out the whys and wherefores thereof.

Anne of Green Gables

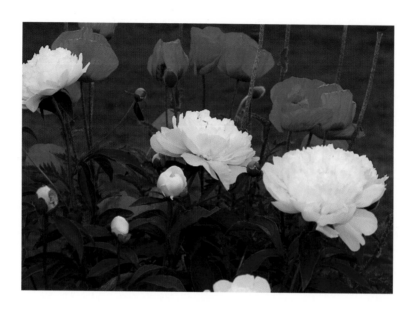

GARDEN PEONIES

The garden was a beautiful place, well worthy Cousin Jimmy's pride. It seemed like a garden where no frost could wither or rough wind blow—a garden remembering a hundred vanished summers. There was a high hedge of clipped spruce all around it, spaced at intervals by tall lombardies. The north side was closed in by a thick grove of spruce against which a long row of peonies grew, their great red blossoms splendid against its darkness.

Emily of New Moon

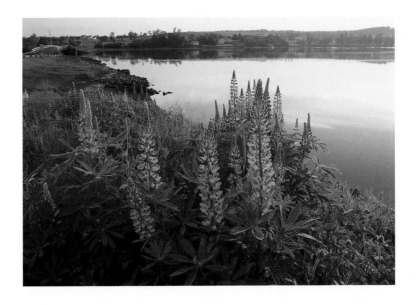

LUPINS

"Oh, look at Indian Head. I could be a sun worshipper this very moment."

Indian Head was a flaming mount of splendour. The far-off hills turned beautifully purple against the radiant sky. Even the bare, ugly Hardscrabble Road was transfigured and luminous in hazes of silver. The fields and woods were very lovely in the faint pearly luster.

"The world is always young again for just a few moments at the dawn," murmured Emily.

Emily Climbs

of spruce against which a

splendid against its darkness.

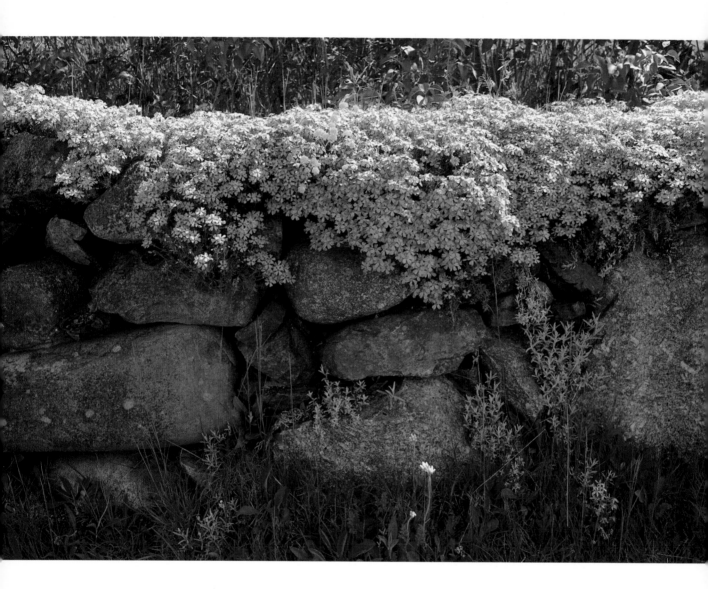

WALLED GARDEN

And meanwhile here was a beautiful garden over the wall which looked as if it should be full of children. But no children were ever in it—or anybody else apparently. And so, in spite of its beauty, it had a lonely look that hurt Jims. He wanted his Garden of Spices to be full of laughter. He pictured himself running in it with imaginary playmates—and there was a mother in it—or a big sister—or, at the least, a whole aunt who would let you hug her and would never dream of shutting you up in a chilly, shadowy, horrible blue room.

"It seems to me," said Jims, flattening his nose against the pane, "that I must get into that garden or bust."

"The Garden of Spices"

"It seems to me," said Jims, flattening his nose against the pane, "that I must get into that garden or bust."

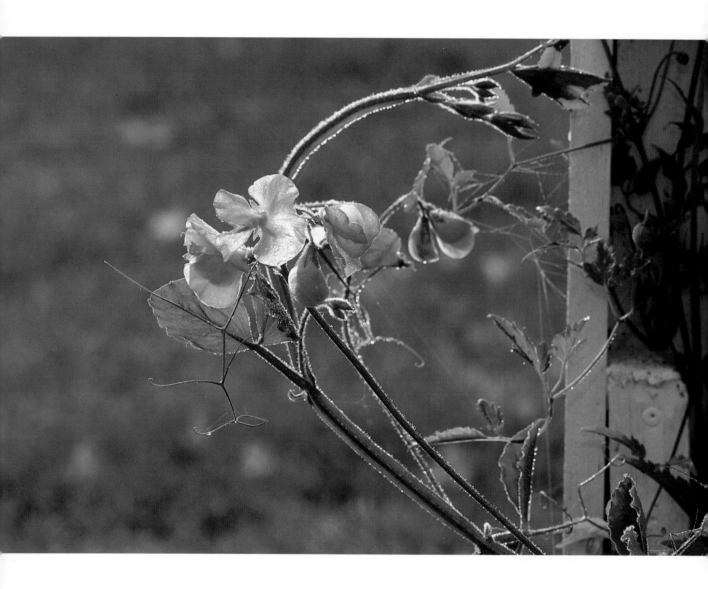

SWEET PEAS

"...if dryads are foolish they must take the consequences, just as if they were real people," said Paul gravely. "Do you know what I think about the new moon, teacher? I think it is a little golden boat full of dreams."

"And when it tips on a cloud some of them spill out and fall into your sleep."

"Exactly, teacher. Oh, you do know. And I think the violets are little snips of the sky that fell down when the angels cut out holes for the stars to shine through. And the buttercups are made out of old sunshine; and I think the sweet peas will be butterflies when they go to heaven. Now, teacher, do you see anything so very queer about those thoughts?"

"No, laddie dear, they are not queer at all; they are strange and beautiful thoughts for a little boy to think, and so people who couldn't think anything of the sort themselves, if they tried for a hundred years, think them queer. But keep on thinking them, Paul...some day you are going to be a poet, I believe."

Anne of Avonlea

"And the buttercups are made out of old sunshine; and I think the sweet peas will be butterflies when they go to heaven."

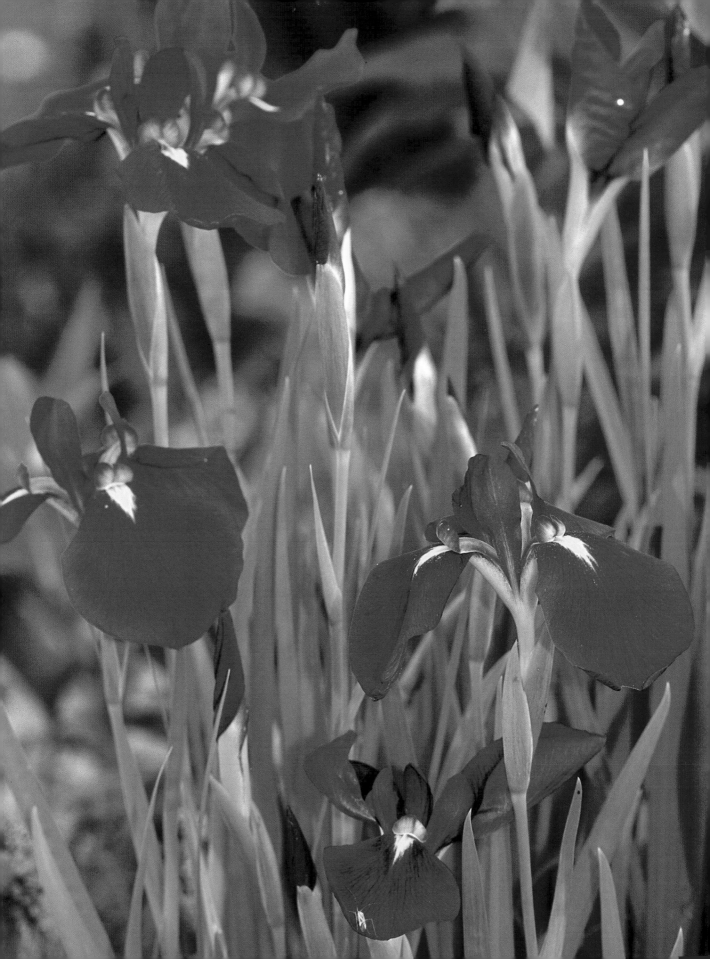

SIBERIAN IRIS

"You never mind letting people have things when you know they love them. And she won't mind our making an iris glade in the spruce bush. That is another thing I've always dreamed of…hundreds of iris with spruce trees around them…all around them, so the glade will never be seen save by those you want to see it. And we can go there when we want to be alone. One needs a little solitude in life."

Mistress Pat

"That is another thing I've always dreamed of…hundreds of iris with spruce trees around them … all around them, so the glade will never be seen save by those you want to see it."

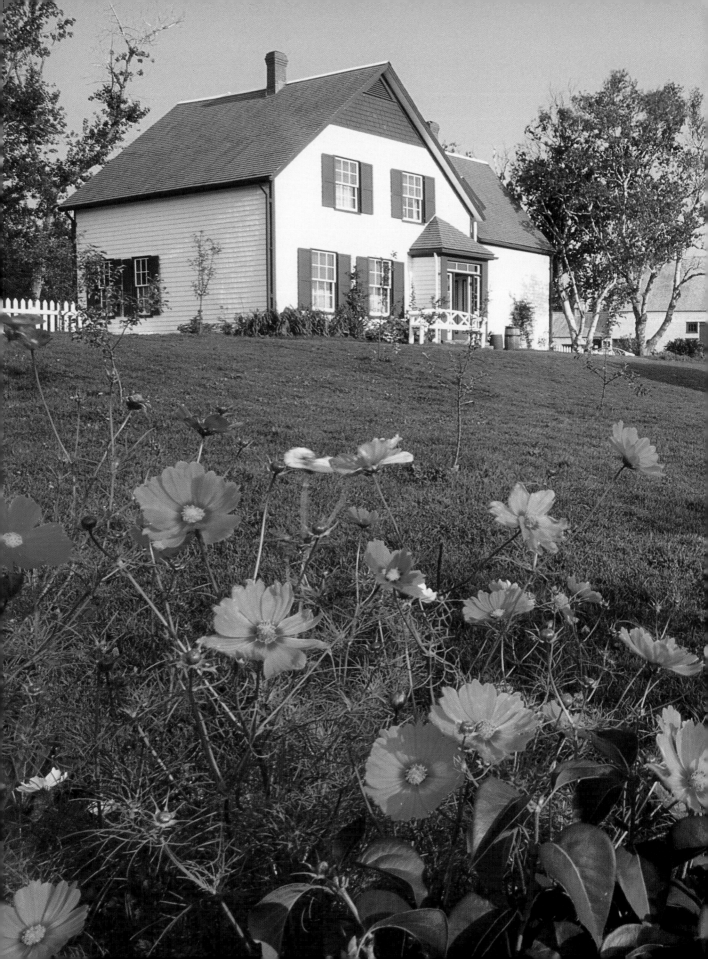

Summer

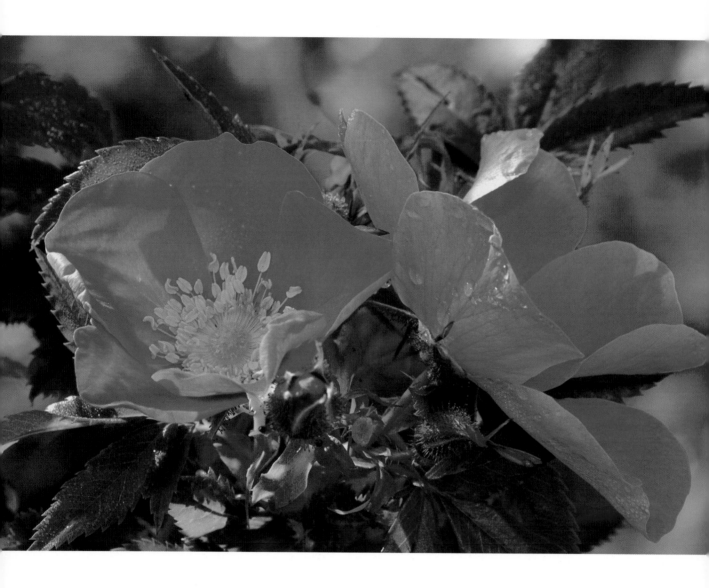

WILD ROSES

"You were right not to come to New York," wrote Miss Royal. "You could never have written The Moral of the Rose here. Wild roses won't grow in city streets. And your story is like a wild rose, dear, all sweetness and unexpectedness with sly little thorns of wit and satire. It has power, delicacy, understanding.

Emily's Quest

"And your story is like a wild rose, dear, all sweetness and unexpectedness with sly little thorns of wit and satire."

KITCHEN GARDEN

"This evening, just when I was in the middle of a story Aunt Elizabeth said she wanted me to weed the onion-bed. So I had to lay down my pen and go out to the kitchen garden. But one can weed onions and think wonderful things at the same time, glory be. It is one of the blessings that we don't always have to put our souls into what our hands may be doing, praise the gods—for otherwise who would have any soul left? So I weeded the onion-bed and roamed the Milky Way in imagination."

Emily's Quest

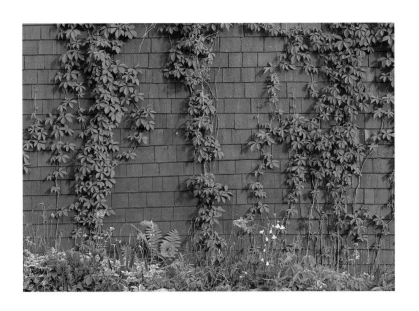

VIRGINIA CREEPER

Anne climbed the ladder amid breathless silence, gained the ridge pole, balanced herself to walk along it, dizzily conscious that she was uncomfortably high up in the world...Then she swayed, lost her balance, stumbled, staggered and fell, sliding down over the sun-baked roof and crashing off it through the tangle of Virginia creeper beneath—all before the dismayed circle below could give a simultaneous, terrified shriek.

Anne of Green Gables

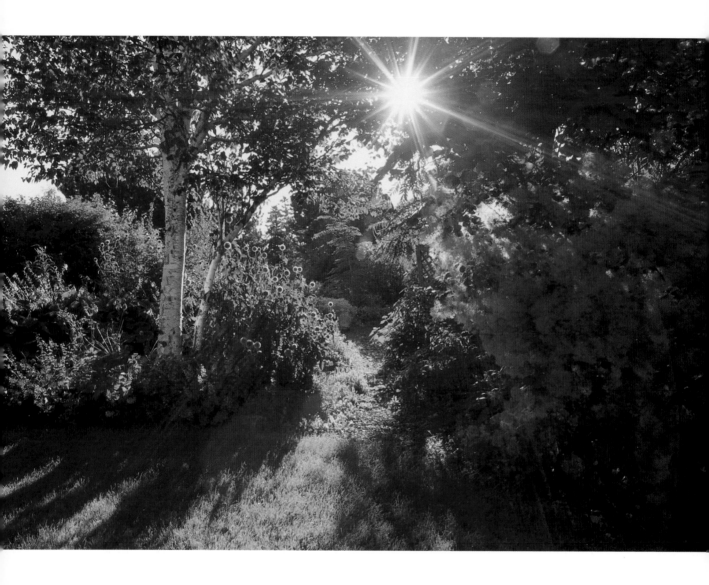

White Birch

There were some young poplars on which the leaves were trembling and in one corner was a slim white birch which Esme knew—but could not have told how she knew—that some long-ago bride had planted.

Here and there were dim paths on which lovers of half a century ago had walked with their ladies. One of the paths, flagged with thin sandstones from the shore, ran through the middle of the garden to the river shore, where there was no fence, only a low stone wall to keep the garden from running into the river.

Fancy's Fool

Here and there were dim paths on which lovers of half a century ago had walked with their ladies.

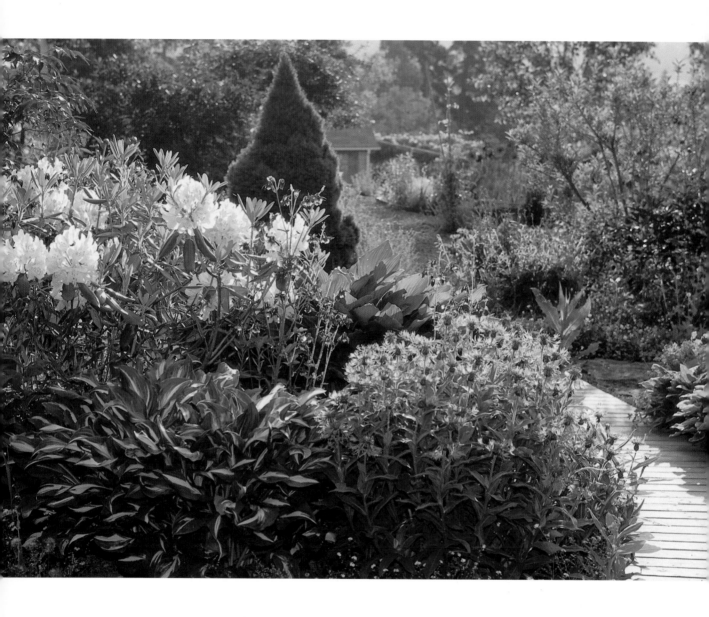

GARDEN IN SHADOW

Westward the sun was sinking low over a far land of shining hills. The air was sweet with a certain blended fragrance that only the Silver Bush garden knew. The whole lovesome place was full of soft amethyst shadows.

Mistress Pat

The whole lovesome place was full of soft amethyst shadows.

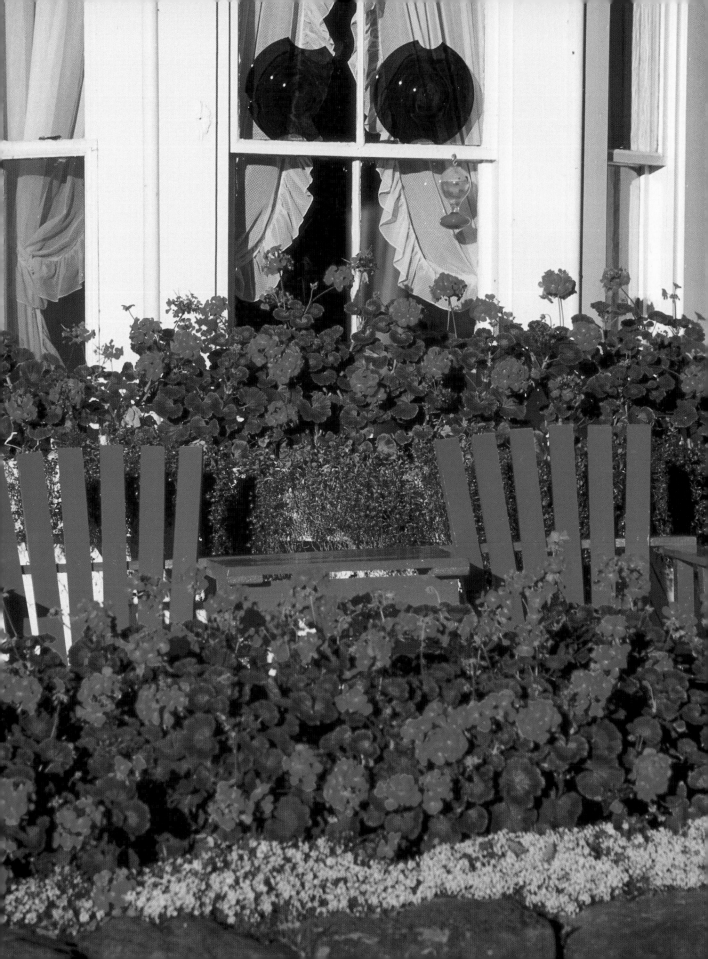

GERANIUMS

We always sat on the verandah in the afternoon, when we were not visiting or being visited. I made a pretence of fancy work, and Aunt Philippa spun diligently on a little old fashioned spinning-wheel that had been her grandmother's. She always sat before the wood stand which held her flowers, and the gorgeous blots of geranium blossom and big green leaves furnished a pretty background.

"Aunt Philippa and the Men"

We always sat on the verandah in the afternoon, when we were not visiting or being visited.

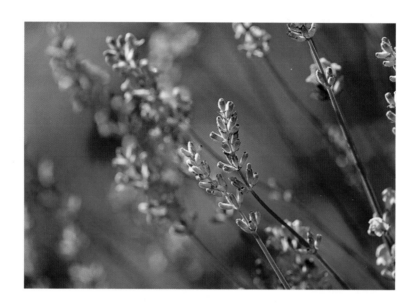

LAVENDER

"I'm going to give you girls a bunch of lavendar apiece," said Miss Lavendar brightly, as if she had not heard the answer to her question. "It's very sweet, don't you think? Mother always loved it. She planted these borders long ago. Father named me Lavendar because he was so fond of it. The very first time he saw mother was when he visited her home in East Grafton with her brother. He fell in love with her at first sight; and they put him in the spare room bed to sleep and the sheets were scented with lavender and he lay awake all night and thought of her. He always loved the scent of lavender after that…and that was why he gave me the name."

Anne of Avonlea

The Wind Woman

tiny fairy and the cats ar

TANSY

The tansy patch is a very *quante* place—especially at night. I love the twilight there. We always have such fun in the twilight. The Wind Woman makes herself small in the tansy just like a tiny, tiny fairy and the cats are so queer and creepy and delightful then.

Emily of New Moon

kes herself small in the tansy just like a tiny,

queer and creepy and delightful then.

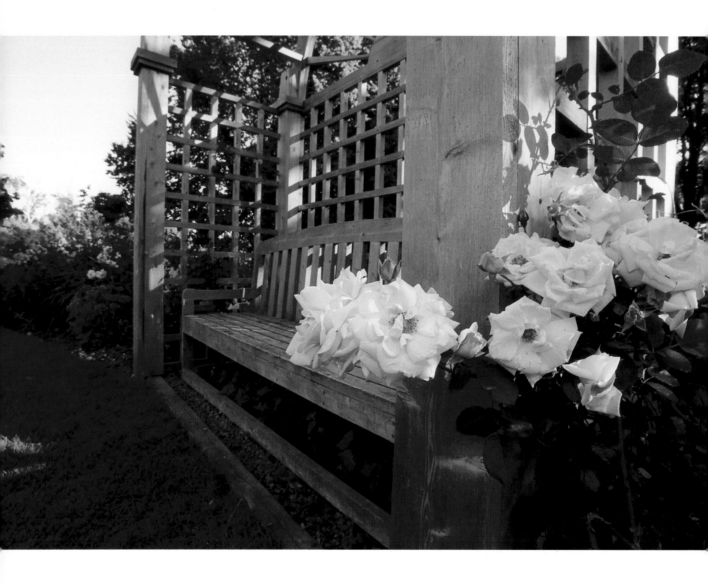

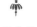

R O S E S

...most of the idyllic hours of Eric's wooing were spent in the old orchard; the garden end of it was now a wilderness of roses—roses red as the heart of a sunset, roses pink as the early flush of dawn, roses white as the snow on mountain peaks, roses full blown, and roses in beds that were sweeter that anything on earth except Kilmeny's face. Their petals fell in silken heaps along the old paths or clung to the lush grasses among which Eric lay and dreamed, while Kilmeny played to him on her violin.

Kilmeny of the Orchard

Their petals fell in silken heaps along the old paths or clung to the lush grasses among which Eric lay and dreamed, while Kilmeny played to him on her violin.

TWILIGHT GARDEN

"Some evenings a strange odour blows down the air of this garden, like a phantom perfume," said Owen. "I have never been able to discover from just what flower it comes. It is elusive and haunting and wonderfully sweet. I like to fancy it is the soul of Grandmother Selwyn passing on a little visit to the old spot she loved so well. There should be a lot of friendly ghosts about this little old house."

Anne's House of Dreams

"It is elusive and haunting and wonderfully sweet."

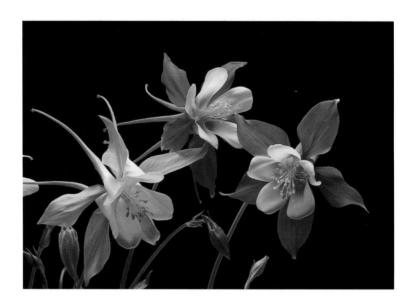

COLUMBINES

This is a wonderful year for columbines. The old orchard is full of them—all in lovely white and purple and fairy blue and dreamy pink colour. They are half wild and so have a charm no real tamed garden flower ever has. And what a name—columbine is poetry itself. How much lovelier the common names of flowers are than the horrid Latiny names the florists stick in their catalogues. Heartsease and Bride's Bouquet, Prince's Feather, Snap-dragon, Flora's Paint Brush, Dusty Millers, Bachelor's Buttons, Baby's Breath, Love-in-a-mist—oh, I love them all.

Emily Climbs

"*It's a fine, marvelous wo*

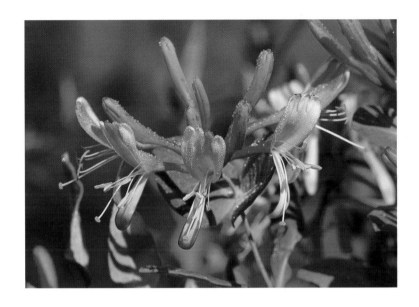

HONEYSUCKLE

The garden was an untidy little place, sloping to the south, which somehow contrived to be pleasant. There was honeysuckle over the paling…"to bring the hummingbirds," said Little Aunt Em…and white and red hollyhocks against the dark green of a fir coppice and rampart tiger lilies along the walk. And one corner was rich in pinks.

"Nice out here, ain't it?" said Little Aunt Em. "It's a fine, marvelous world… oh, it's a very fine, marvelous world. Don't you like life, Jane Stuart?"

Jane of Lantern Hill

oh, it's a very fine, marvelous world."

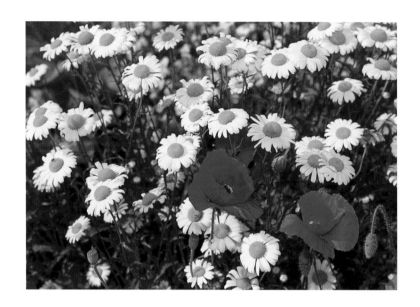

DAISIES, POPPIES

Anne and Gilbert walked hand in hand around the garden. The brook that ran across the corner dimpled pellucidly in the shadows of the birches. The poppies along its bands were like shallow cups of moonlight. Flowers that had been planted by the hands of the schoolmaster's bride flung their sweetness on the shadowy air, like the beauty and blessing of sacred yesterdays.

"I love to smell flowers in the dark," she said. "You get hold of their soul then. Oh, Gilbert, this little house is all I've dreamed it. And I'm so glad that we are not the first who have kept bridal tryst here!"

Anne's House of Dreams

"I love to smell flowers in the dark,

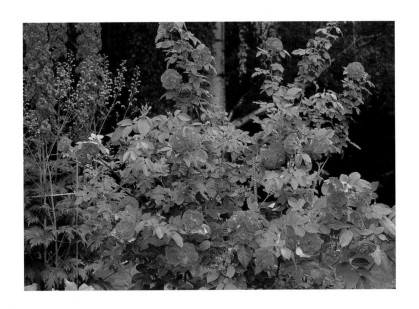

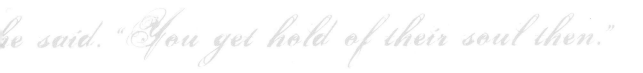

BLUE DELPHINIUMS, ROSES

Pat, at that moment, was working in the garden, at peace with herself and all the world. Somehow, she always felt safe from change in that garden. Just now it seemed to be taking pleasure in itself. Its flowers were guests not prisoners…its blue delphiniums, its frail fleeting loveliness of poppies, its Canterbury bells, delicious mauve flecked with purple, its roses of gold and snow, its lilies of milk and wine.

Mistress Pat

he said. "You get hold of their soul then."

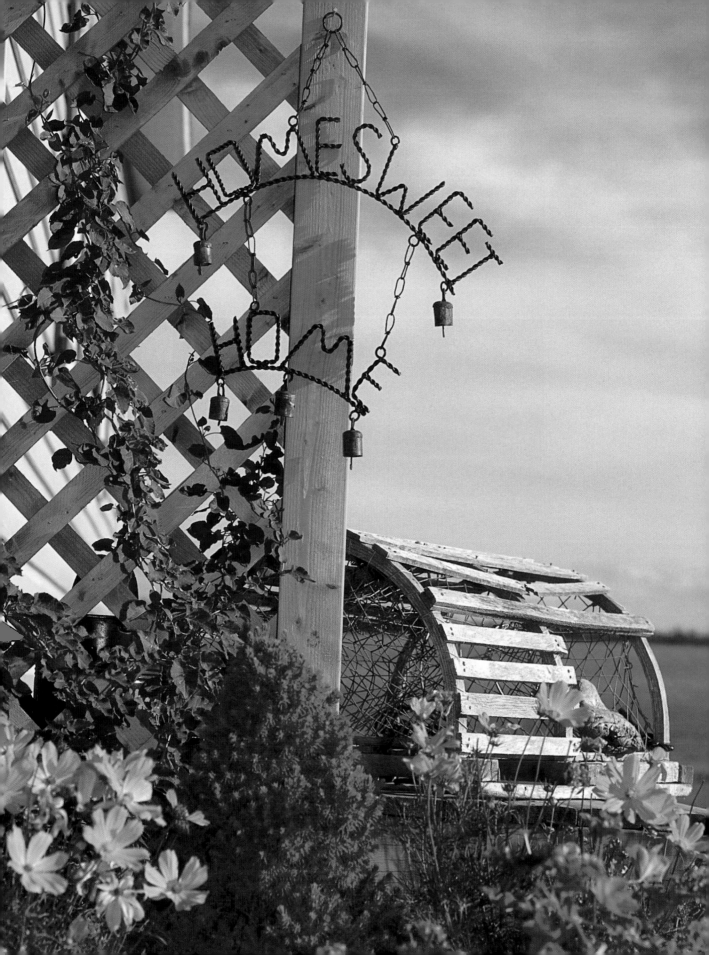

HARBOUR GARDEN

The old garden that faced the fair blue harbour, with its white gate set midway, where darling flowers grew and kittens ran beautiful brief little pilgrimages before they were given away…It had all the beauty of old gardens where sweet women have aforetime laughed and wept. Some bit of old clan history was bound up with almost every clump and walk in it, and already Marigold knew most of it.

Magic for Marigold

It had all the beauty of old gardens where sweet women have aforetime laughed and wept.

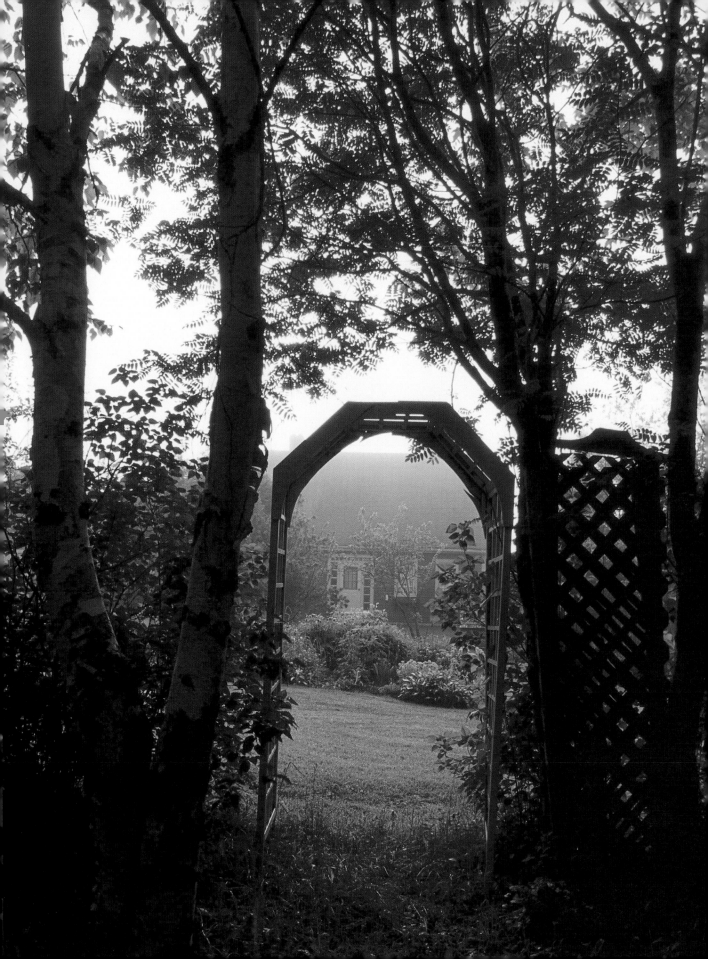

STORYBOOK GARDEN

The Morgan place will suit us in every essential particular—we really can't afford to miss such a chance. Think of that big lawn with those magnificent old trees; and of that splendid hardwood grove behind it—twelve acres of it. What a play place for our children! There's a fine orchard, too, and you've always admired that high brick wall around the garden with the door in it—you've thought it was so like a story-book garden. And there is almost as fine a view of the harbour and the dunes from the Morgan place as from here.

Anne's House of Dreams

Think of that big lawn with those magnificent old trees; and of that splendid hardwood grove behind it— twelve acres of it.

Autumn

C H I N E S E L A N T E R N

One day a wind blew through the Ingleside garden…the first wind of autumn. That night the rose of the sunset was a trifle austere. All at once the summer had grown old. The turn of the season had come.

Anne of Ingleside

All at once the summer had grown old. The turn of the season had come.

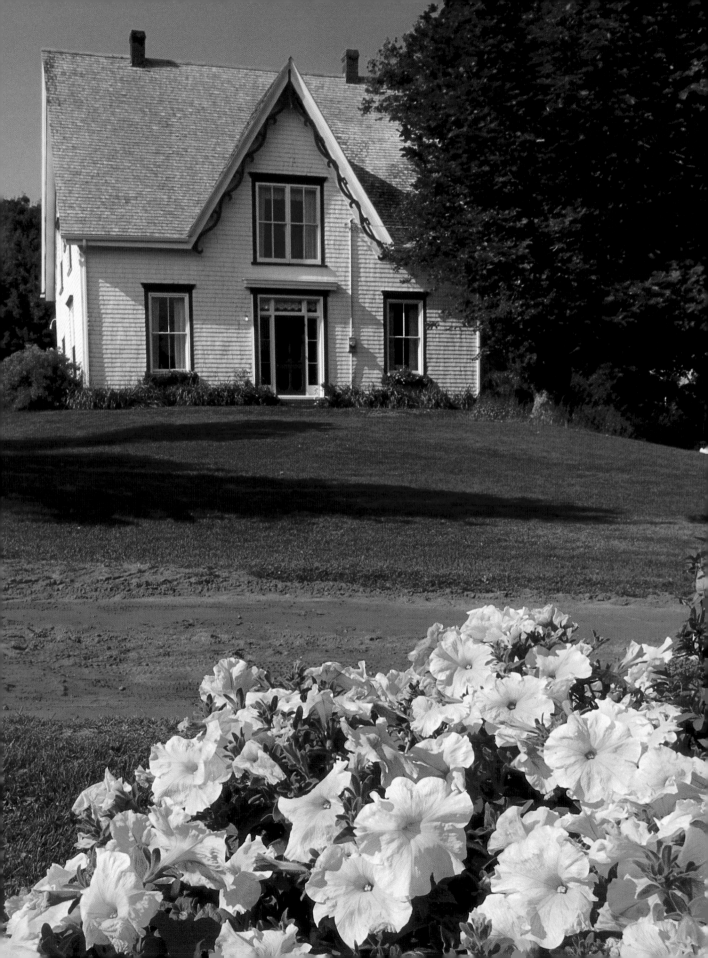

SILVER BUSH

Autumn was here…the air was full of its muted music. The old farm lay before her in the golden light of the mellow September evening. She knew every kink and curve of it. Every field was an intimate friend. The Pool glimmered mysteriously. The round window winked at her. The trees she had grown up with waved to her. The garden was afoam with starry white cosmos backed by the stately phalanx of the Prince's Feather. Dear Silver Bush! Never had she felt so close to it…so one with it.

Pat of Silver Bush

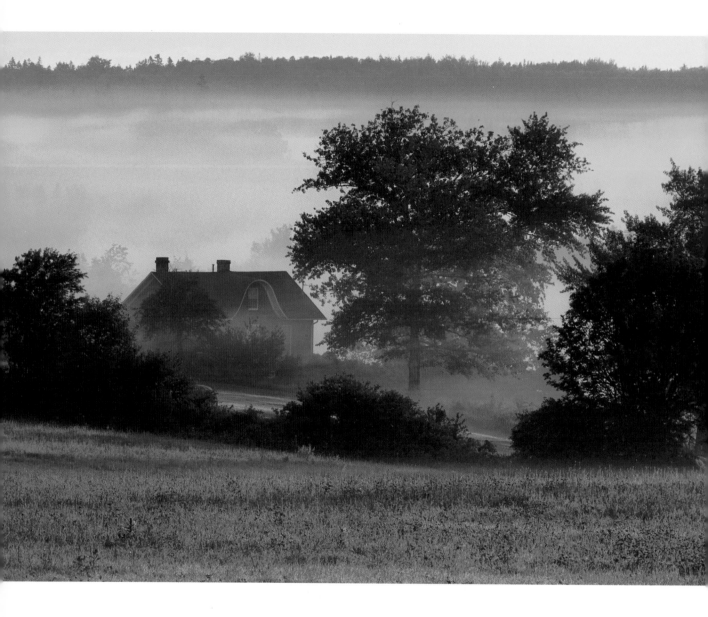

THE STONE HOUSE,
CLYDE RIVER

The cat ran over the lawn and Jims pursued it through the green gloom of the thickly clustering trees. Beyond them came a pool of sunshine in which the old stone house basked like a huge grey cat itself. More garden was before it and beyond it... Under a huge spreading beech tree in the center of it was a little tea table; sitting by the table reading was a lady in a black dress.

"The Garden of Spices"

More garden was before it and beyond it...

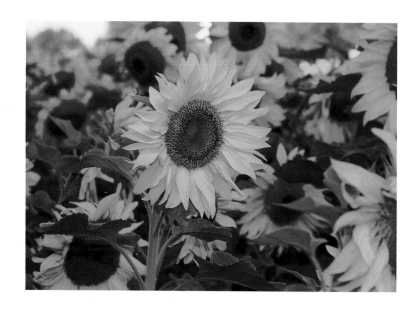

SUNFLOWERS

We worked persistently, and took our consolation out of a few hardy sunflowers which, sown in an uncared for spot, throve better than all our petted darlings, and lighted up a corner of the spruce grove with their cheery golden lamps.

The Alpine Path

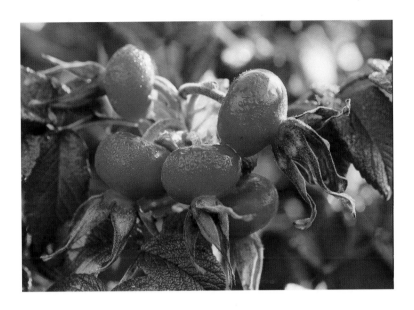

R O S E H I P S

Necklaces of roseberries are very much worn now.

It is considered smart to wear your school hat tilted over your left eye.

Bangs are coming in. Em Frewen has them. She went to Summerside for a visit and came back with them. All the girls in school are going to bang their hair as soon as their mothers will let them. But I do not intend to bang mine.

The Golden Road

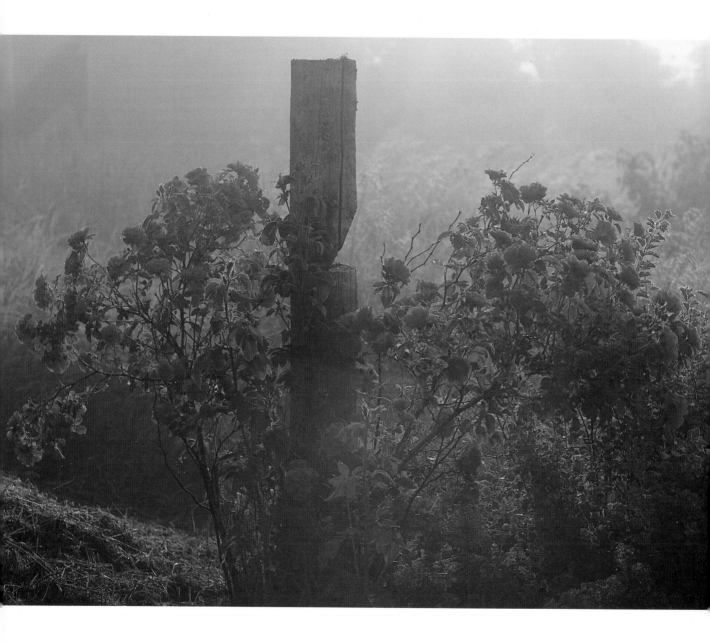

Haunted Garden

She paused for a moment to look about her on hills and woods she had loved in olden days and still loved. Dear Avonlea! Glen St. Mary was home to her now and had been home for many years but Avonlea had something that Glen St. Mary could never have. Ghosts of herself met her at every turn…the fields she had roamed in welcomed her…unfading echoes of the old sweet life were all about her…every spot she looked upon had some lovely memory. There were haunted gardens here and there where bloomed all the roses of yesteryear.

Anne of Ingleside

There were haunted gardens here and there where bloomed all the roses of yesteryear.

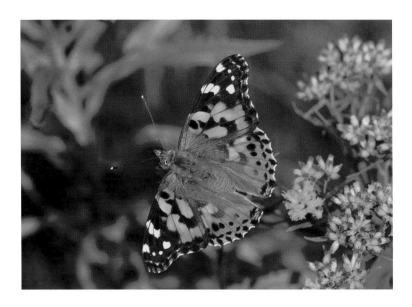

GOLDENROD

It was a lovely afternoon—such an afternoon as only September can produce when summer has stolen back for one more day of dream and glamour. Harvest fields drenched in sunshine lay all around them: the austere charm of northern firs made wonderful the ways over which they walked: goldenrod beribboned the fences and the sacrificial fires of willow-herb were kindled on all the burnt lands along the sequestered roads back among the hills.

Emily Climbs

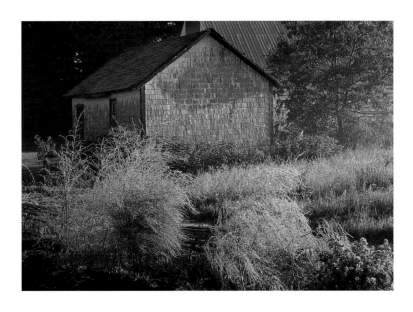

Asparagus Fern

November was a dismal month that year…a month of east wind and fog. Some days there was nothing but cold mist driving past or drifting over the grey sea beyond the bar. The shivering poplar trees dropped their last leaves. The garden was dead and all its colour and personality had gone from it…except the asparagus-bed, which was still a fascinating golden jungle.

Anne of Ingleside

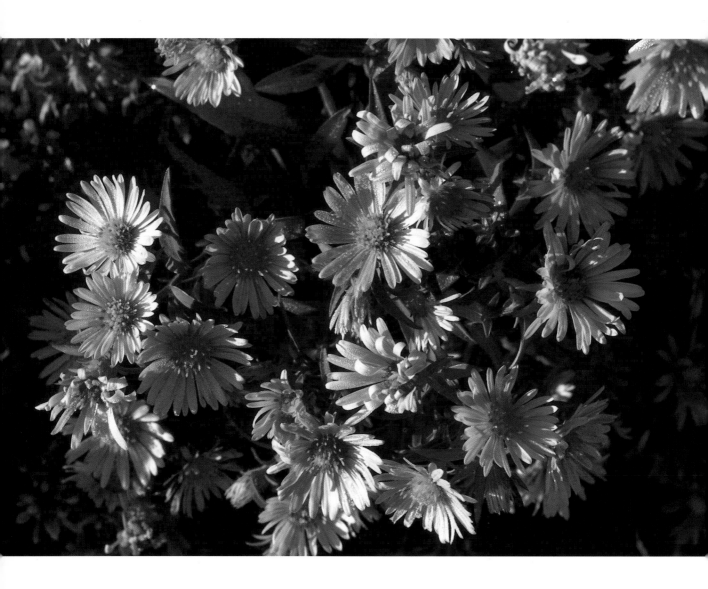

WILD ASTERS

"...I can see the moonlight shining white and still on the old hills of home. It has seemed to me ever since I came here that it was impossible that there could be calm gentle nights and unshattered moonlight anywhere in the world. But tonight somehow, all the beautiful things I have always loved seem to have become possible again—and this is good, and makes me feel a deep, certain, exquisite happiness. It must be autumn, at home now—the harbour is a-dream and the old Glen hills blue with haze, and Rainbow Valley a haunt of delight with wild asters blowing all over it, —our old 'farewell-summers'. I always liked that name so much better then 'aster'—it was a poem in itself."

Rilla of Ingleside

"...I can see the moonlight shining white and still on the old hills of home."

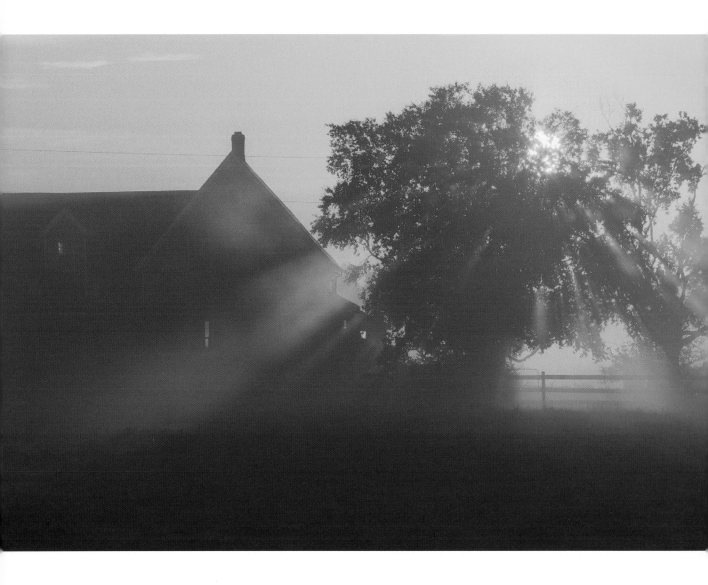

SUNRISE

Rilla woke that morning when the dawn was beginning to break and went to her window to look out, her thick creamy eyelids heavy with sleep. Just at dawn the world looks as it never looks at any time. The air was cold with dew and the orchard and grove and Rainbow Valley were full of mystery and wonder. Over the eastern hill were golden deeps and silvery-pink shallows. There was no wind, and Rilla heard distinctly a dog howling in a melancholy way down in the direction of the station.

Rilla of Ingleside

Just at dawn the world looks as it never looks at any time.

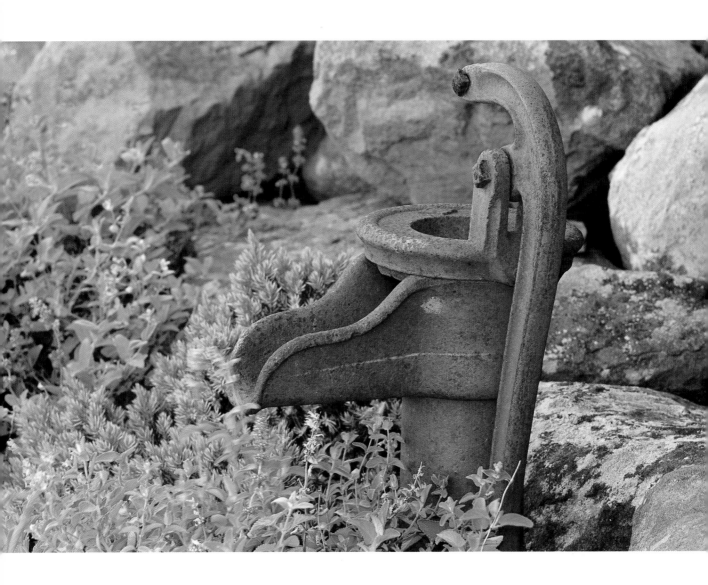

Pump & Herbs

A very old woman, who looked at Jims with great amazement, came out to set the table. Jims thought she must be as old as Methusaleh. But he did not mind her. He ran races with Black Prince while tea was being prepared, and rolled the delighted cat over and over in the grass. And he discovered a fragrant herb-garden in a far corner and was delighted. Now it was truly a garden of spices.

"The Garden of Spices"

And he discovered a fragrant herb-garden in a far corner and was delighted. Now it was truly a garden of spices.

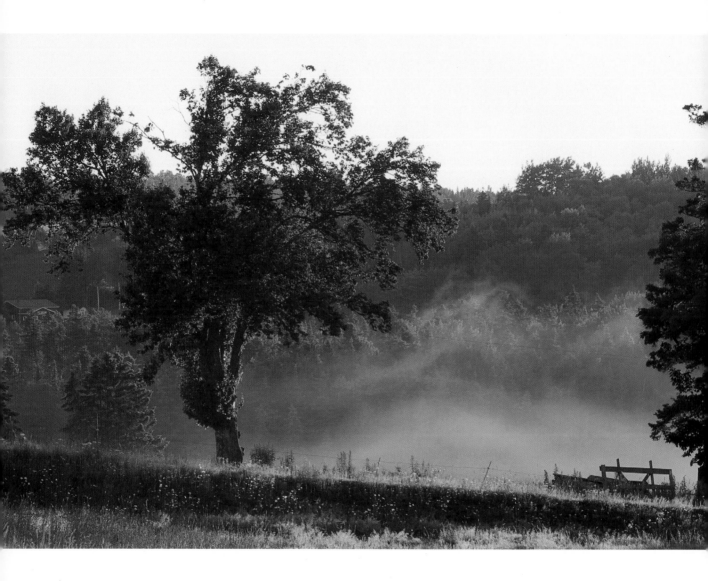

DUSK

The dusk crept into the orchard like a dim, bewitching personality. You could see her—feel her—hear her. She tiptoed softly from tree to tree, ever drawing nearer. Presently her filmy wings hovered over us and through them gleamed the early stars of the autumn night.

The Story Girl

The dusk crept into the orchard like a dim, bewitching personality.

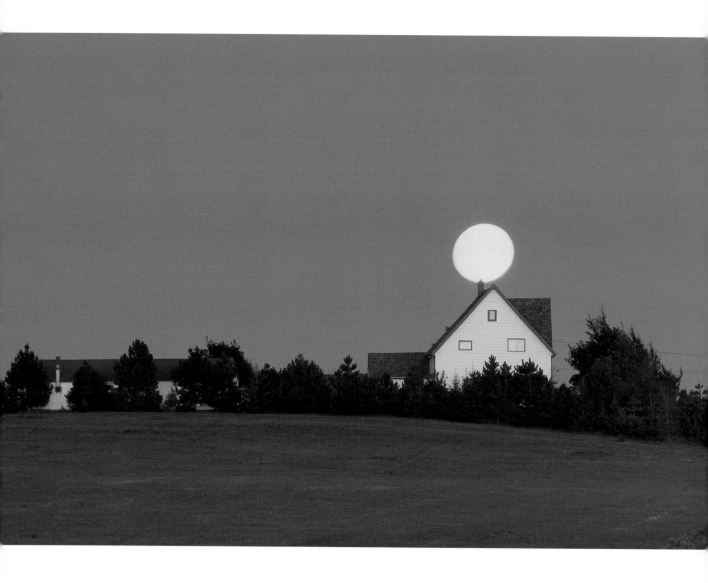

Moonlight

It was dark in the hall, where no lamp had been lighted, but outside on the lawn the moonlight was bright as day. It was the clearest, whitest night I ever saw. I turned aside into the garden, meaning to cross it, and take the short way over the west meadow home. There was a long walk of rose bushes leading across the garden to a little gate on the further side…the way Mr. Lawrence had been wont to take long ago when he went over the fields to woo Margaret. I went along it, enjoying the night. The bushes were white with roses, and the ground under my feet was all snowed over with their petals. The air was still and breezeless; again I felt that sensation of waiting…of expectancy.

"The Girl at the Gate"

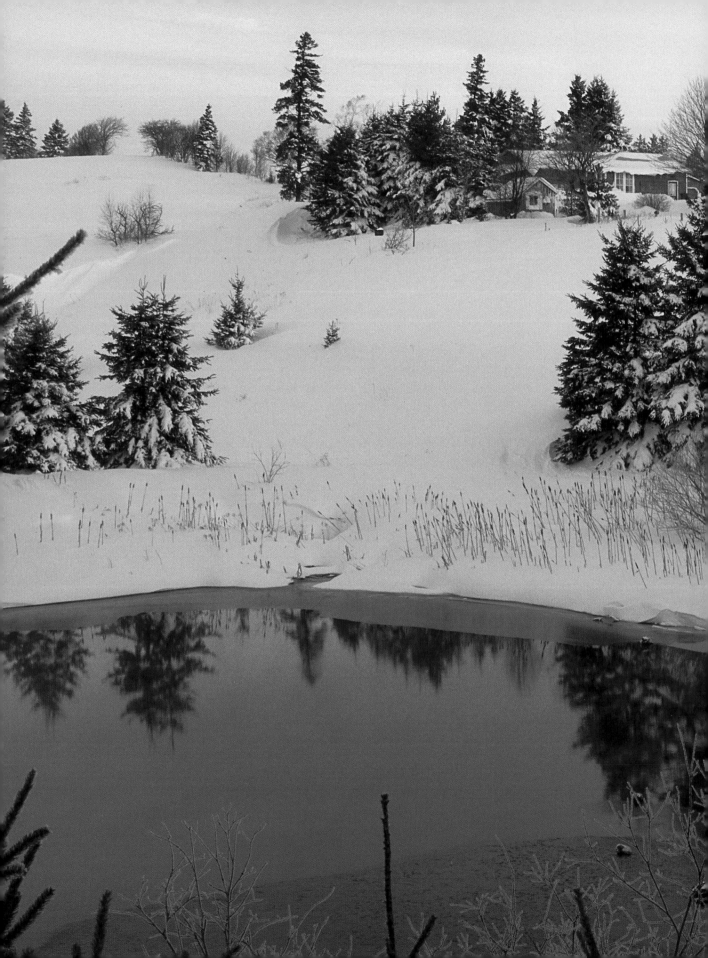

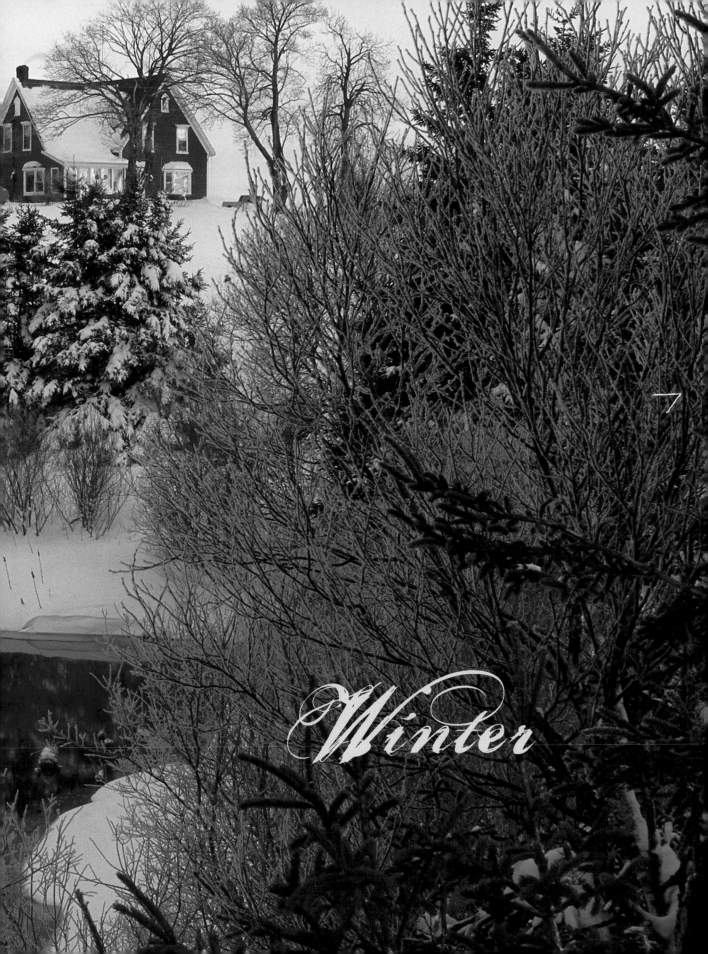

Winter

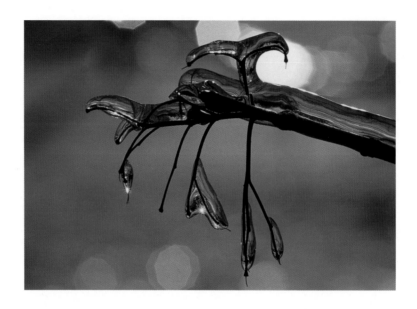

✳

FIRST SNOW

The first snow came one afternoon as she wrote, in flakes as large as butterflies. Would it be snowing on the Island? Jane hunted up the morning paper and looked to see what the weather report in the Maritimes was.

Yes…cold, with showers of snow…clearing and cold at night. Jane shut her eyes and saw it. Great soft flakes falling over the grey landscape against the dark spruces…her little garden a thing of fairy beauty…egg flakes in the empty robin's nest she and Shingle knew of…the dark sea around the white land. "Clearing and cold at night." Frosty stars gleaming out in still frostier evening blue over quiet fields thinly white with snow.

Jane of Lantern Hill

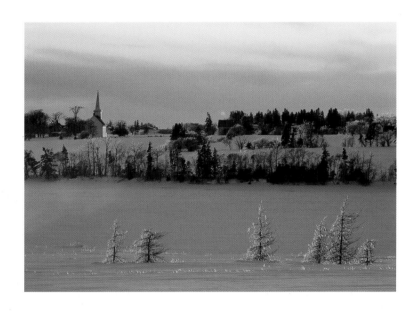

NIGHT MUSIC

And it was, as I remember it, a most exquisite night—a white poem, a frosty, starry lyric of light. It was one of those nights on which one might fall asleep and dream happy dreams of gardens of mirth and song, feeling all the while through one's sleep the soft splendour and radiance of the white moon-world outside, as one hears soft, far-away music sounding through the thoughts and words that are born of it.

The Golden Road

n still frostier

nly white with snow.

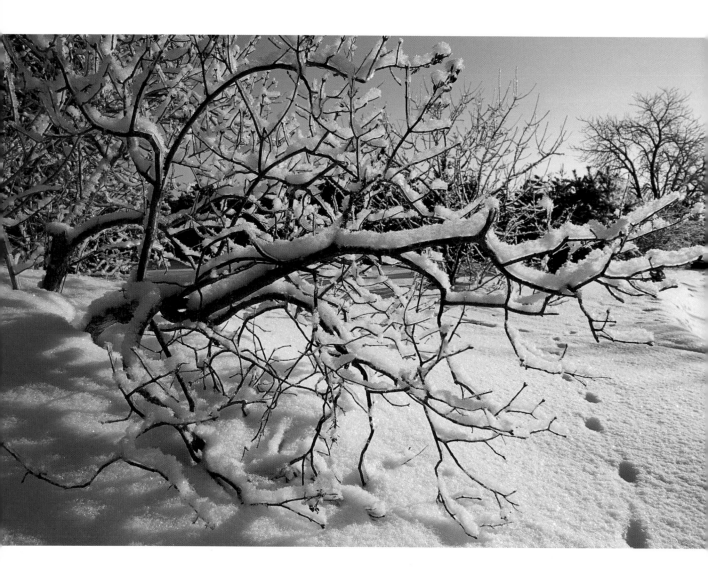

* * *

CHRISTMAS IN THE GARDEN

Christmas morning broke on a beautiful white world. It had been a very mild December and people had looked forward to a green Christmas; but just enough snow fell softly in the night to transfigure Avonlea. Anne peeped out from her frosted gable window with delighted eyes. The firs in the Haunted Wood were all feathery and wonderful; the birches and wild cherry trees were outlined in pearl; the ploughed fields were stretches of snowy dimples; and there was a crisp tang in the air that was glorious. Anne ran downstairs singing until her voice re-echoed through Green Gables.

Anne of Green Gables

Anne peeped out from her frosted gable window with delighted eyes.

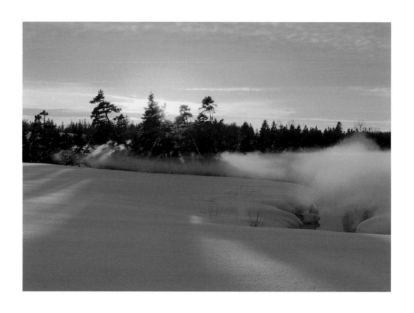

✳

WINTER SUNSET

She lingered at the gate to taste her happiness after Sid had gone on to the barn. It was going to be a night of frost and silver. To her right the garden was hooding itself in the shadows of dusk. Pat loved to think of all her staunch old flowers under the banks of snow, waiting for spring. Far away a dim hill came out darkly against a winter sunset. Beyond the dyke was a group of old spruces which Long Alec often said should be cut down. But Pat pleaded for them. Seen in daylight they were old and uncomely, dead almost to the top, with withered branches. But seen in this enchanted light, against a sky that began by being rosy-saffron and continued in silver green, and ended in crystal blue, they were like tall, slender witch women weaving spells of necromancy in a rune of olden days. Pat felt a stirring of her childish desire to share in their gramarye…to have fellowship in their twilight sorceries.

Mistress Pat

＊

GOOD CHEER

… in the library or the big kitchen the children planned out their summer playhouse in the Hollow while storms howled outside, or fluffy white clouds were blown over frosty stars. For blow it high or blow it low there was always at Ingleside glowing fires, comfort, shelter from storm, odours of good cheer, beds for tired little creatures.

Christmas came and went undarkened this year by any shadow of Aunt Mary Maria. There were rabbit trails in the snow to follow and great crusted fields over which you raced with your shadows and glistening hills for coasting and new skates to be tried out on the pond in the chill, rosy world of winter sunset.

Anne of Ingleside

think of all her staunch old flowers under

, waiting for spring.

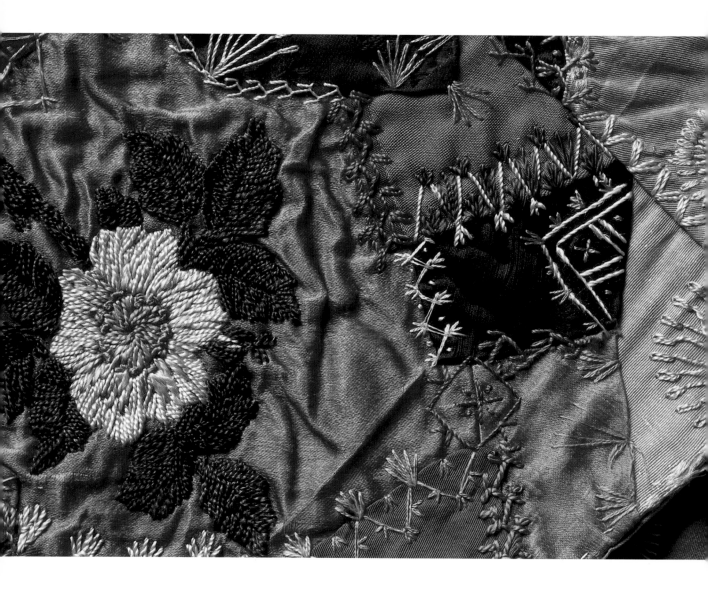

*

L.M. MONTGOMERY'S
CRAZY QUILT

"I'll think on these things and go to bed. What a quilt to sleep under! I wonder if I'll be as crazy as it by morning. And this is a spare room! I've never forgotten what a thrill it used to give me to sleep in any one's spare room."

Anne of Windy Poplars

"What a quilt to sleep under! I wonder if I'll be as crazy as it by morning."

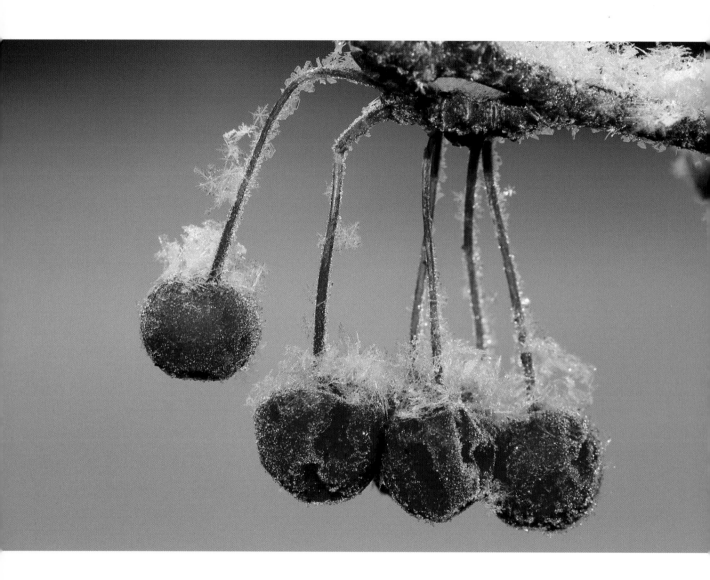

✳

ORCHARD PEARLS

It was winter in our orchard of old delights then—so truly winter that it was hard to believe summer had ever dwelt in it, or that spring would ever return to it. There were no birds to sing the music of the moon; and the path where the apple blossoms had fallen were heaped with less fragrant drifts. But it was a place of wonder on a moonlit night, when the snowy arcades shone like avenues of ivory and crystal, and the bare trees cast fairy-like traceries upon them. Over Uncle Stephen's Walk, where the snow had fallen smoothly, a spell of white magic had been woven. Taintless and wonderful it seemed, like a street of pearl in the new Jerusalem.

The Golden Road

There were no birds to sing the music of the moon; and the path where the apple blossoms had fallen were heaped with less fragrant drifts.

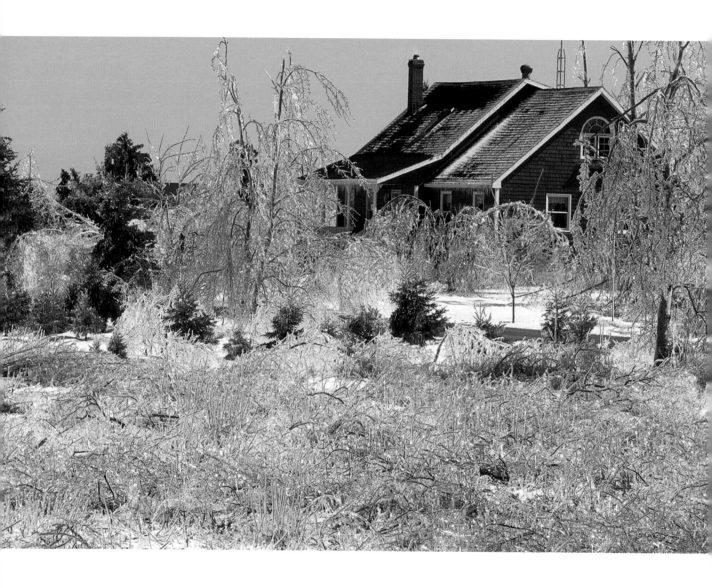

✳

JUST AS PRETTY

I think the garden is just as pretty in winter as in summer. There are such pretty dimples and baby hills where the snow has covered up the flower beds. And in the evenings it is all pink and rosy at sunset and by moonlight it is like dreamland. I like to look out of the sitting-room window at it... and wonder what all the little roots and seeds are thinking of down under the snow.

Emily of New Moon

I think the garden is just as pretty in winter as in summer.

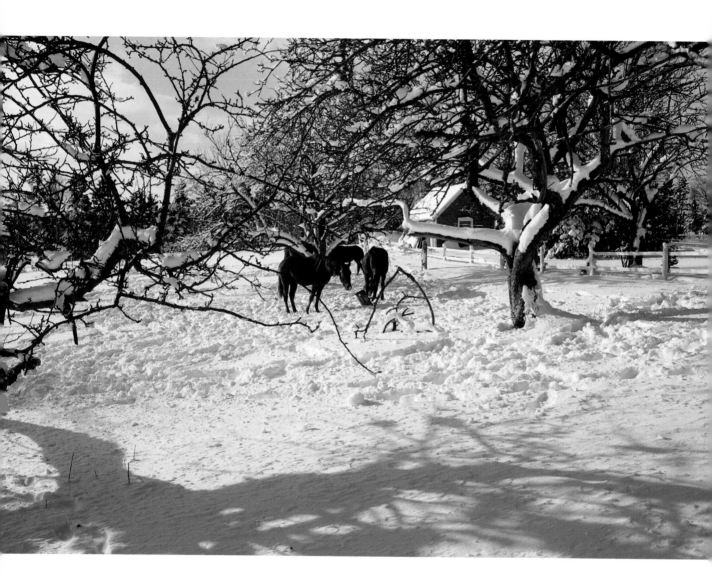

*

HORSES IN THE ORCHARD

It was a diamond winter day in February—clear, cold, hard, brilliant. The sharp blue sky shone, the white fields and hills glittered, the fringe of icicles around the eaves of Uncle Alec's house sparkled. Keen was the frost and crisp the snow over our world; and we young fry of the King households were all agog to enjoy life—for was it not Saturday, and were we not left all alone to keep house?

The Golden Road

The sharp blue sky shone, the white fields and hills glittered, the fringe of icicles around the eaves of Uncle Alec's house sparkled.

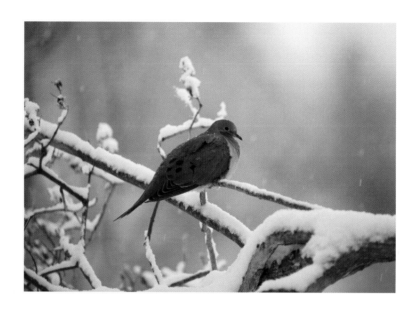

✳

SPRING IS COMING

Off to her left the orchard was white and still, heaped with drifts along the fences. Over it all was a delicate tracery of shadow where the trees stood up lifeless in seeming death and sorrow. But it was only seeming. The life-blood was in their hearts and by and by it would stir and they would clothe themselves in bridal garments of young green leaves and pink blossoms, and lush grass would wave where the snow was now lying and golden buttercups dance among it. Spring always came again…she must never forget that.

Mistress Pat

Spring always came again… she must never forget that.

L. M. Montgomery:
LIST OF WORKS CITED

"The Girl at the Gate" (1906) in *Among the Shadows: Tales from the Darker Side*. Ed. Rea Wilmshurst. Toronto: McClelland & Stewart, 1990.

Anne of Green Gables, 1908. New York: Grosset & Dunlap, 1935.

Anne of Avonlea, 1909. Toronto: McGraw-Hill Ryerson, 1942.

Kilmeny of the Orchard, Boston: L.C. Page & Co.,1910.

"A Garden of Old Delights." *Canadian Magazine*, June 1910.

The Story Girl, 1911. Toronto: McGraw-Hill Ryerson, 1944.

The Golden Road, 1913. Toronto: McGraw-Hill Ryerson, 1944.

Anne of the Island, 1915. Toronto: McGraw-Hill Ryerson, 1942.

The Alpine Path, 1917. Don Mills, ON: Fitzhenry & Whiteside, 1975.

Anne's House of Dreams, 1917. Toronto: McClelland & Stewart, 1922.

Rainbow Valley, 1919. Don Mills, ON: McClelland & Stewart, 1923.

Rilla of Ingleside, 1920. Toronto: McClelland & Stewart, 1922.

Emily of New Moon, 1923. Toronto: McClelland & Stewart, 1934.

Emily Climbs, 1925. Toronto: McClelland & Stewart, 1925.

Emily's Quest, 1927. Toronto: McClelland & Stewart, 1947.

Magic for Marigold, 1927. Don Mills, ON: McClelland & Stewart, 1927.

A Tangled Web, 1931. Toronto: McClelland and Stewart, 1972.

Pat of Silver Bush, 1933. Toronto: McClelland & Stewart, 1977.

Mistress Pat, 1935. Toronto: McClelland & Stewart, 1977.

Anne of Windy Poplars, 1936. Toronto: McClelland & Stewart, 1936.

Jane of Lantern Hill, 1937. Toronto: McClelland & Stewart, 1937.

Anne of Ingleside, 1939. New York: Grosset & Dunlop, 1939.

Fancy's Fool, The Road to Yesterday. Toronto: McGraw-Hill Ryerson, 1974.

"The Garden of Spices" in *The Doctor's Sweetheart and Other Stories*. Ed. Catherine McKay. Toronto: McGraw-Hill Ryerson, 1979.

The Selected Journals of L.M. Montgomery. Volume I 1889–1910. Ed. Mary Rubio and Elizabeth Waterston. Toronto: Oxford University Press, 1985

The Selected Journals of L.M. Montgomery. Volume II 1910–1921. Ed. Mary Rubio and Elizabeth Waterston. Toronto: Oxford University Press, 1987.

The Selected Journals of L.M. Montgomery. Volume III 1921–1929. Ed. Mary Rubio and Elizabeth Waterston. Toronto: Oxford University Press, 1992.

"Aunt Philippa and the Men" in *At the Altar: Matrimonial Tales*. Ed. Rea Wilmshurst. Toronto: McClelland & Stewart, 1994.

Scrapbook #4. L.M. Montgomery Institute, University of Prince Edward Island.

✦

AFTERWORD

The idea for *A Writer's Garden* was developed over many years. I grew up at "Silver Bush," the home that L. M. Montgomery called "the wonder castle of my childhood." I recall the many beautiful descriptions written by L. M. Montgomery and read to us by my father. These were matched by the beauty of the old-fashioned flowers on our property, which my mother spent many happy hours gardening. I felt that L. M. Montgomery's passages and the loveliness of the gardens and orchards on Prince Edward Island should be preserved and shared.

In Montgomery's *Emily Climbs*, Emily wonders if her "Chronicles of an Old Garden" could be accepted for publication. Maybe this is it.

Knowing photographer Anne MacKay from our school days in Kensington, and knowing of writer Sandy Wagner's love for L. M. Montgomery's words, it seemed a kindredly combination to work with these two individuals and share the idea for this book. This is not a gardening book as such, but in gathering its contents we have truly found a writer's garden.—*George Campbell*